Tacita Dean
Five Americans

Edited by
Massimiliano Gioni
and
Margot Norton

Contents

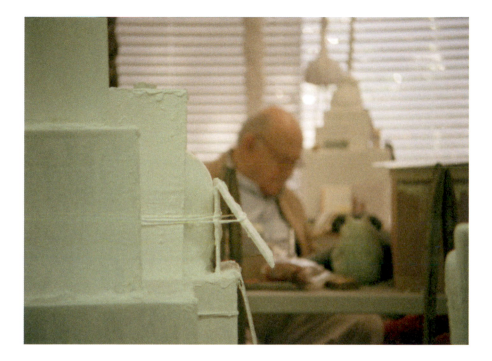

Edwin Parker, 2011 (still). 16mm color film, optical sound, 29 min

Foreword

The New Museum is proud to present "Tacita Dean: Five Americans," the largest New York exhibition to date by the celebrated British artist and filmmaker. Since the mid-1990s, Tacita Dean has realized a subtle and sophisticated body of work in film, photography, drawing, and writing which captures the fortuitous moments of chance and wonder that animate the built and natural world. This presentation focuses on portraiture as a continuous theme within Dean's work and presents 16mm films as well as related works that profile significant, creative, American figures: choreographer Merce Cunningham, artists Julie Mehretu, Claes Oldenburg, and Cy Twombly, and art historian Leo Steinberg. In these works, Dean discovers the unanticipated moments of inspiration, contemplation, and reflection that define the creative life. "Tacita Dean: Five Americans" is part of a series of exhibitions inaugurated last year focusing on a single project or body of work within an artist's larger practice. Following projects by Gustav Metzger and Apichatpong Weerasethakul, this exhibition provides a unique opportunity to look at the way in which Dean views creativity across mediums and engages with our shared cultural history.

I would like to thank Massimiliano Gioni, Associate Director and Director of Exhibitions, who along with Margot Norton, Curatorial Associate, initiated this project and worked closely with Tacita Dean over many months to realize this intellectually and aesthetically rich exhibition. I would also like to thank Gary Carrion-Murayari, Curator, and Jenny Moore, Assistant Curator, who contributed throughout the exhibition planning. Joshua Edwards, Director of Exhibitions Management, Victoria Manning, Assistant Registrar, Shannon Bowser, Chief Preparator, Kelsey Womack, Exhibitions Assistant, and Greg Kalliche, brought immense effort, creativity, and patience to the installation plan-ning and execution. The exhibition would not have been possible without the support of the entire Museum staff and in particular I would like to thank Karen Wong, Deputy Director and Director of External Affairs, and Regan Grusy, Associate Director and

Director of Development, who, along with their respective teams, contributed greatly to making the show possible.

This exhibition would not have been realized without the assistance of KS Objectiv, who has worked closely with Tacita Dean and our installation team to solve the many technical challenges of the installation, and Anita Tscherne, assistant to the artist, who provided additional and much-needed support. I am also extremely grateful for the support of Tacita Dean's galleries Marian Goodman Gallery in New York and Frith Street Gallery in London who helped make the exhibition possible from beginning to end. In particular, I would like to thank Rose Lord, Director, Brian Loftus, Registrar, Catherine Belloy, Archivist, and Linda Pellegrini, Director of Communications, at Marian Goodman Gallery as well as Dale McFarland, Associate Director, at Frith Street Gallery for all of their hard work.

The exhibition has been made possible by the generosity of the Leadership Council of the New Museum. This catalogue includes a text by Massimiliano Gioni exploring the unique experience of time which Dean's work both captures and creates for the viewer. Writing has always been a significant part of Dean's practice and the book also includes several short texts by the artist herself on each of the works in the exhibition, providing illuminating personal insight into this collection of films and objects. Finally, fellow artist Mark Wallinger contributes a rich reflection on the connections between poetry, film, and the transience of creative thought. I would like to thank all of the catalogue contributors, as well as New Museum Copy Editor and Publications Coordinator, Sarah Stephenson, for making such a rich complement to the show. All of the catalogues in this ongoing series of exhibitions have been elegantly designed by Purtill Family Business. Above all, I would like to thank Tacita Dean for her inspired vision and generous collaboration which made this project a reality.

Lisa Phillips
Toby Devan Lewis Director, New Museum

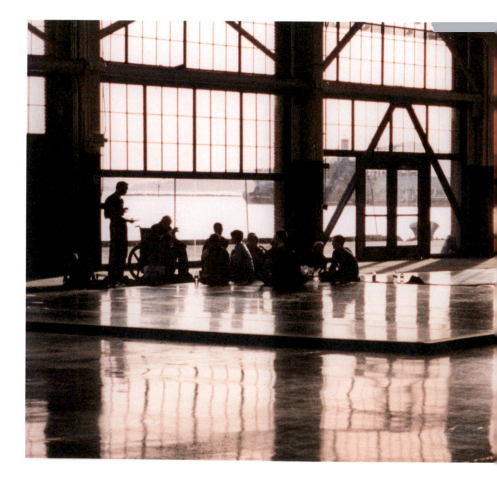

Craneway Event, 2009 (still). 16mm anamorphic film, color, optical sound, 108 min

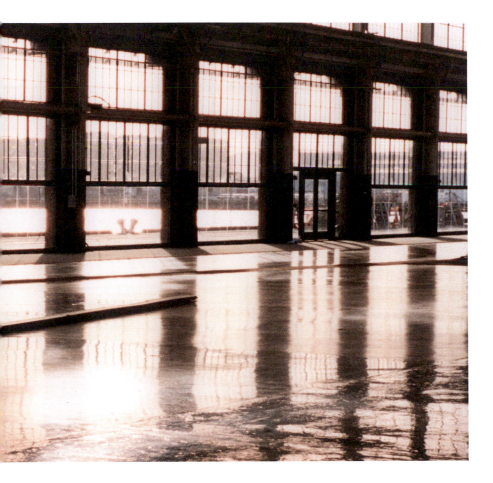

In Praise of Slowness:
Notes on Tacita Dean's Sense of Time

Massimiliano Gioni

Time is a tyrant. In one of Goya's most celebrated paintings, Chronos, the god of time, devours his children: one could see this as a premonition of the twentieth century, of what Eric Hobsbawm would call "the short century"; the century without time. Tacita Dean's work is full of paternal images as well as images of the elderly, but in a reversal of Goya's painting, her films keep the past alive—children observe their parents, with a gaze that perpetuates their existence. Chronos is preserved by his children.

Perhaps today the role of the artist is to slow time down. The ultimate weapon of the avant-garde is boredom: time stretched so far that it stands still, time reduced to stasis. During the Spanish Civil War, anarchists would shoot at the clocks on bell towers, as if the revolution was meant to arrest the dictatorship of time. Dean is an anarchist, but a mild-mannered one: she is literally a woman of a different time.

Bell towers are a fourteenth-century invention: Some churches adopted them earlier, some later, but in any case, bell towers made their appearance in European cities just as a new concept of time was taking hold. This cultural transformation is the subject of French historian Jacques Le Goff's study *Time, Work, & Culture in the Middle Ages*, in which he quotes a thirteenth-century text by Guillaume d'Auxerre: "Augustine says that every creature is obliged to give of itself; the sun is obliged to give of itself in order to shine; in the same way, the earth is obliged to give all that it can produce, as is the water. But nothing gives of itself more in conformity with nature than time; every thing has time."[1] "And time has everything," one might add, as it's hard to tell who owns whom in this relationship. We talk about "spending time," but it is time that spends us, consumes us, and buries us.

In Dean's work, the sun gives of itself endlessly. The earth gives of itself endlessly. Sometimes the sun even gives of itself on command, as in her film *The Green Ray* (2001), which is usually presented with a button that lets one activate the sunset sequence

10

The Green Ray, 2001 (stills). 16mm film, color, silent, 2:30 min

at whim. Just push a key, and the sun offers itself up, in real time.

What is "real time," exactly? There's an ambiguity in the phrase that is symptomatic of the confusion our society feels about time. "In real time" can mean "immediately"—for example, election results are announced "in real time," to signify "at the same time as they are known." But the same phrase is used to describe events that play out before us slowly, without interruption, implying that the timeframe of a fictional event is synchronized with the passing of time in the real world. It is in this latter sense that we say, for example, that a scene in a movie is shot in real time. The meanings of the two expressions are diametrically opposed and yet they are described with the same choice of words, because our language harbors a deep confusion between immediacy and dilation, speed and slowness. Despite appearances, very few of Dean's films unfold in real time. Even the longest and most stretched out are carefully edited; in her films, time is always constructed, never just recorded.

Dean's work overflows with creatures and things that give of themselves freely, that take all the time they need. "Still lifes" is one of the ways in which Dean has described her films. And it is an expression that hides another intriguing semantic confusion: "still life" means "motionless life," of course, but can also be read as "life, once again."

Stillness is the title of the dance that renowned choreographer Merce Cunningham composed and performed in front of Dean's camera. In Dean's homonymous installation, *Merce Cunningham performs STILLNESS...* (2008), six films portray Cunningham, almost at the end of his life, performing for the first time to *4' 33''*, John Cage's legendary composition that consists of four minutes and thirty-three seconds of silence—and all the noises that silence is made up with. This piece is charged with personal memories, as Cage and Cunningham were joined in life in a partnership that was both professional and romantic. In *Merce Cunningham performs STILLNESS...*, Cunningham is dancing but also perhaps reminiscing; he remains motionless to grasp time and its memory. Here, Chronos is literally paralyzed, his appetite frozen in time.

Yet time can never be stopped. Watching the film closely, the director of Cunningham's dance company—reflected in a mirror—can be seen signaling to Cunningham at the end of every movement in the score. At each cue, Cunningham changes his pose and then remains immobile for the duration of the next movement.

Another digression: in the score for *4'33''*, John Cage writes "Tacet" to indicate silence. Tacet, Latin for "it is silent," has the same root as the artist's name: Tacita, "the silent one." Dean's work is full of silences that, like Cage's music, are seething with noise. And even her silent films are accompanied by the whir of the projector, spinning like an accelerated clock.

Dean's entire oeuvre is an allegory of time. The films in *Merce Cunningham performs STILLNESS...* are not just the portrait of a great dancer as he performs to a composition by a great musician. The director who signals the end of the movements holds a watch in his hand: a young man literally counting out the time that the old man has left. There's a pitiless expression in Italian, *avere i minuti contati*—literally, "his minutes are counted"—that is used to mean "he's out of time," "his days are numbered." Like in a Renaissance painting, Dean composes an allegorical portrait that could be titled "The Ages of Man."

In *Craneway Event* (2009), Dean portrays a completely different Cunningham. The Cunningham we see here is a master putting the final touches on his chef d'oeuvre to complete a sweeping fresco, and revealing himself to be just as extroverted, meticulous, and determined as he seemed introverted and nostalgic in *Merce Cunningham performs STILLNESS....* Of course, there are scenes of Cunningham nodding off in the middle of rehearsal, but these sequences feel more like a confirmation of his unflagging energy than the portrait of a drained, faltering man. This energy is heightened by the lithe, athletic bodies of the young dancers who are shown moving through the vast spaces of the craneway pavilion in Richmond, California, with the light of the sunset shimmering across its reflective surfaces of cement, glass, and metal. *Craneway Event* is a visual symphony that may be devoid of music, yet resonates with tempos of *andante* and *allegro*. It is the opposite of *Merce Cunningham performs*

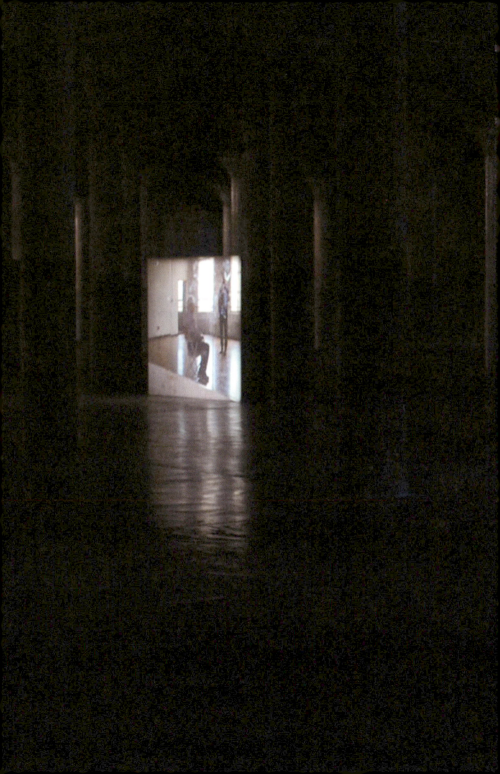

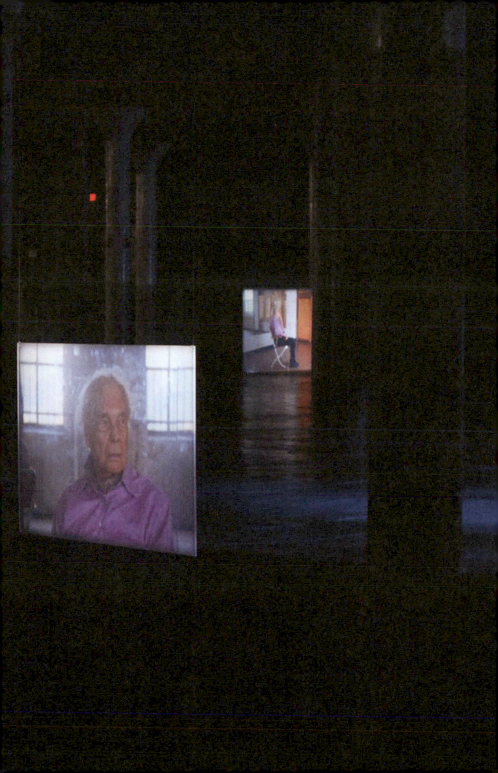

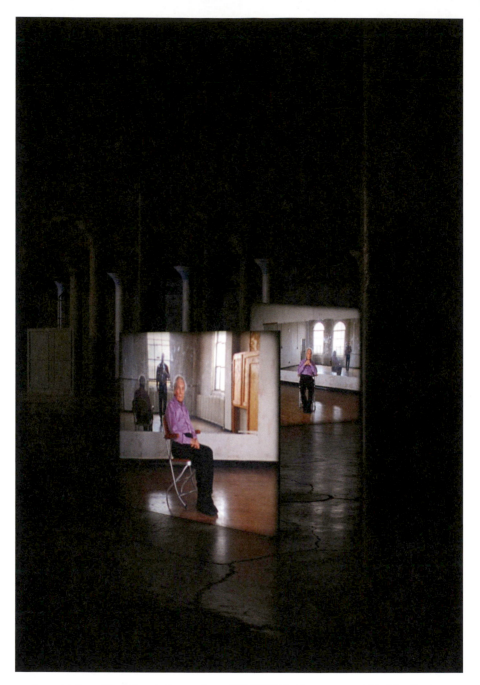

previous and above: *Merce Cunningham performs STILLNESS (in three movements) to John Cage's composition 4'33" with Trevor Carlson, New York City, 28 April 2007 (six performances; six films)* (stills), 2008. Six 16mm films, color, optical sound, approx. 5 min each. Installation view: Dia:Beacon, New York

STILLNESS…: here all is action and movement, *luxe* and *volupté*, light and life.

Craneway Event also presents a different conception of time: a chrono-logic in which the linear notion is replaced by an image of time as a field of simultaneous occurrences. After all, Cunningham himself came up with a completely ahistorical vision of his artistic output in his "Events": these retrospectives in movement are presentations of choreographies in which movements, steps, and figures, conceived in different periods, are recombined as if in a collage, letting go of any academic or temporal perspective in favor of a synchronic idea of space and time. In the "Events," everything happens in the same moment and in the same place—time has expanded.

Italian artist Gino De Dominicis, at the age of twenty-five, published his *Letter on Immortality* in which he wrote: "To truly exist, we must stand still in time." In the work of Dean, immobility is cultivated as a form of ecology. Tacita Dean's work is full of images, but unlike the commercial ones that pollute our lives and cities, hers are slow and dense, with an enormous specific weight. I've always thought of Dean as the Richard Serra of vision: her images are as heavy as gigantic sculptures.

Some of Dean's films are true monuments, involuntary ones perhaps, but monuments nonetheless, preserving the image of our fathers and forefathers for eternity. Every time I see one of her films, I think of Virgil, of Aeneas and Anchises, the son bearing his father on his back. Merce Cunningham, Mario Merz, and, more recently, Claes Oldenburg and Cy Twombly are just some of the father-figures whose images Dean has captured for us. And there is something desperately touching about Dean's attempt to defy time: she tries to forever capture the image of our great teachers, literally rendering them immortal, fixing their effigy on a medium—film stock—which is itself inevitably destined to disappear. How long will the sentimental encyclopedia Dean is composing still be visible? The idea that work so deeply devoted to defeating obsolescence is itself doomed to oblivion may be a sign of the times.

There is another film by Dean that clearly addresses this idea of the portrait as a monument: *Human Treasure* (2006) is

17

a cinematic investigation into the life of Sensaku Shigeyama, a Japanese actor who has achieved legendary status in his country and has been proclaimed a living monument. In Dean's film, we watch him walk around, eat, and act. He is a monument who does nothing but exist, but the attentive gaze that Dean trains on him makes us wonder whether existence itself, in all its humdrum, boring simplicity, is what makes our lives so unique.

Dean's films can be pitiless in their simplicity at times, because they have a unique flair for debunking legends even as they are celebrating and helping to build them. In *Edwin Parker* (2011), her cinematic portrait of Cy Twombly, Dean does not depict the artist as a veteran painter lost in his fictional Arcadia, enveloped in a dream of DIY classicism. She does not film Twombly in his house in Gaeta, in Italy, where he spent most of the year among Roman sculptures and landscapes *à la* Poussin. Twombly is shown in his studio in Lexington, Virginia, and at a local diner. And not coincidentally, Dean chooses Twombly's given name as the title for her portrait of the artist as a common man.

Likewise, Dean offers a modest, unassuming image of Claes Oldenburg, filmed as he examines, dusts off, and files away the trifling objects and knickknacks that make up his *Manhattan Mouse Museum* (2011). In similar ways, Dean's artist portraits present their subjects stripped of all heroism, caught up in everyday chores and banal routines, as if to suggest that art is what you do in your empty moments: art is a way of wasting time, of killing time. Alfred Hitchcock once said that cinema is life with all the dull bits cut out. But Dean's films include all the most useless trifles, the dullest details, as if to remind us that this is where life truly lies hidden, in the background noise.

Explaining how his parents used to take him to the movies when the picture had already started, Umberto Eco describes this experience of being plunged into the dark theater as not really being all that different from everyone's experience of life. We stumble into life with the film already underway and must gradually work out who the main characters are, who the extras are, and reconstruct their bonds of friendship and kinship. The only thing we know for certain is that sooner or later, it will be over.

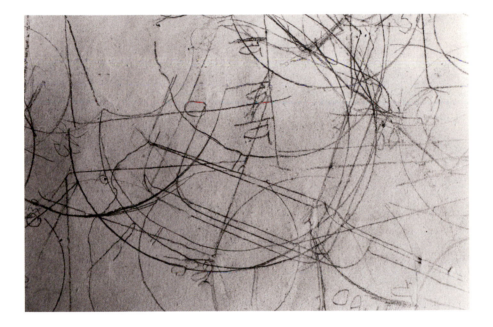

Still Life I-VI, 2009 (detail). Black-and-white photographs on fiber paper, each 22⅞ x 33⅛ in (58 x 84 cm)

Perhaps cinema attracts us precisely because it is a story that resembles life, but gives us the chance to see the beginning and the end. Dean's films foil this expectation of clarity, however: hers is a form of cinema that is much closer to the cinema of the origins. There is no plot, no climax, sometimes there is no beginning and no end. As in the early films by the Lumière brothers, in Dean's films nothing really happens, or—better—everything just happens, everything just gives of itself in front of the camera. And for this reason, Dean's films are much less reassuring than any traditional movie—no matter how artful. Her films are not narratives, they are more like tapestries and it is easy to lose oneself in them. Dean's films are life presented as a chaos to be unraveled, a discovery to be made.

Apparently, the Italian painter Giorgio Morandi did not like going to the cinema but once a week welcomed the visit of a child he had befriended who would sit in his studio and tell him the plots of movies he had seen. Undoubtedly, Morandi had no interest in cinema because too many things that happen in films and cinematic images lack the metaphysical purity that the Italian painter chased in his work. A few years ago, Dean was granted access to Morandi's studio—still perfectly preserved in his house—and came out with two brief, intense films.

For his entire life, Morandi played an extenuating chess game with his objects, his bottles, jugs, and boxes. While Duchamp ushered in the twentieth century with his focus on trivial, aseptic objects, Morandi explored the secret magic that objects preserve when they become part of our lives, when, as if by osmosis, they turn into mirrors of our existence. Dean filmed Morandi's objects in a way Morandi himself would never have painted them: crowded together under artificial light, like a family album of the painter's nearest and dearest.

In another brief work, Dean filmed the sheets of paper onto which Morandi traced the position of his objects, moving them around in search of the perfect composition. These sheets are crisscrossed with hundreds of marks and lines, showing the infinite possible combinations that led to each of his still lifes. Dean was the first ever to document the existence of these involuntary

drawings by Morandi: an important contribution to art history, but also a unique testament to a lifetime devoted to painting. Morandi's "accidental Twomblys," as Dean calls them, are the cartography of an obsession, maps of an immobile existence spent between the four walls of a studio, weaving arabesques in an attempt to sort out that infinite chaos that is life.

Notes
1. Jacques Le Goff, *Time, Work, & Culture in the Middle Ages*, trans. Arthur Goldhammer (University of Chicago Press, 1982), 290.

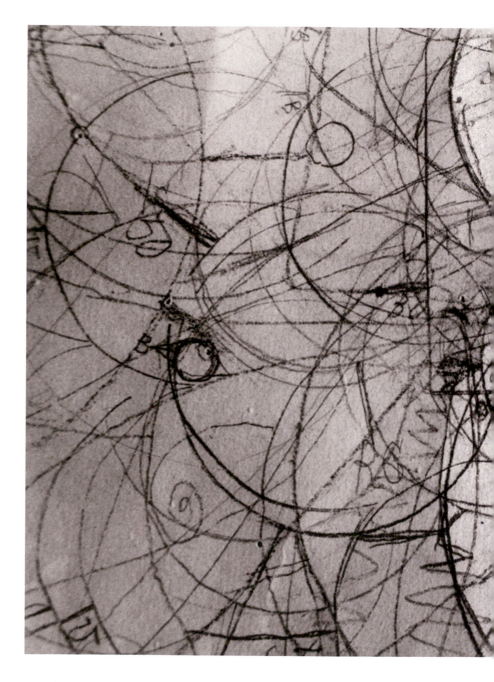

Still Life I-VI, 2009 (detail). Black-and-white photographs on fiber paper, each 22⅞ x 33⅛ in (58 x 84 cm)

Unheard Music
Mark Wallinger

"Heard melodies are sweet, but those unheard / are sweeter"
—John Keats, "Ode on a Grecian Urn"

Keats is described as "this dying creature" by Cy Twombly as
he tells the story of the consumptive poet's tortuous journey to
Rome. "I have an habitual feeling of my real life having past, and
that I am leading a posthumous existence,"[1] Keats wrote in his
last ever letter.

We have grown used to seeing the dead living on film, but
in a sense every recorded action is posthumous. The person
recorded will be lost eventually and inevitably; nostalgia is merely
the warm-up act. To that extent film, like poetry, is intrinsically
elegiac and commemorative.

"Poetry is beauty only to the extent and power of its truth,
its tragic sense of itself as a made and perishing thing."[2] The ode
is a lyrical verse written in praise of, or dedicated to someone
or something, which captures the poet's interest or serves as an
inspiration. For Keats, it was a memorial urn, made to contain
the ashes of the cremated dead for an eternity. Film measures
out a little portion of our finitude to be replayed forever and this
magic is measured in feet, in time and the distance run. The illu-
sion of continuous movement that film produces when reduced
to its component frames is as still as Keats's "unravish'd bride of
quietness."[3] Poetry and film are analogues; the precepts and prec-
edents of language and tradition have to be negotiated to move
on. Keats's Odes were a new form forged out of the poet's dissat-
isfaction with the sonnet form and involved a radical reworking
of a classical mode. Similarly, Tacita Dean has taken film—a form
apparently becoming obsolete—and with an acute appreciation
of its legacy has forged a radical way forward by allowing it to
thrive anew through a heightened awareness of its distinct nature,
allowing the medium to efface the *auteur*: "A poet is the most
unpoetical of any thing in existence; because he has no iden-
tity—he is continually informing—and filling some other body."[4]

Given leave to inhabit the images in long takes, the viewer enters a poetic space cleared of narrative for the ever reiterative "now" each frame proposes. Dean's work is often shown with the projector as part of the experience of the piece and from home movie to film club comes the memory of the spool rewinding to the start. This has a particular poignancy in the capturing of subjects in her ongoing series of film portraits. All film has the capacity to be looped, to join head to tail. In my end is my beginning.

In *Edwin Parker* (2011), we open and close the film with the studio blinds drawn and the windows shuttered. Hinged on ambiguity, a shutter is both a guard against being seen and a device for looking: in photography, of course, it opens and closes to expose the film in a camera. And colloquially, to put up the shutters is the final closing down: never to be seen or looked at again. But on film, letter and parcel can still reach Edwin Parker at his studio—a shop front in Lexington, Virginia, where he is a local artist. We know he is a famous old man and famous old men make late work. But here we see him between times, with friends, opening the mail, reading an article on Larry in the *Financial Times*, lunching at the neighborhood diner. Then it is closing time, people go home, and as the light fades in the studio on the stuff of his sculpture, the plinths and other standing plaster forms receding in space are transfigured into the Forum at night. Cy is back in Rome.

In a series of photographs called "The Somnambulists," Joanna Kane had access to an archive in Edinburgh of historic life masks, including the Romantic poets: Keats, Coleridge, Wordsworth, and Blake. In her work these were lit in dramatic chiaroscuro so that we appear to have the photographic images of people decades before the advent of the medium. They play on the indexical relationship the cast and the photographic image have with reality. Light fell on silver nitrate; John Keats's features were molded in plaster and this cast was the result. Both are created by the touch of something real.

In film, people exist in and out of time. The experience of looking is both phenomenal and reflective simultaneously, like coming to an understanding. Film therefore has this incredible

authority as a medium, and because it understands everything as light it is a projection on the cerebral cortex, an extension of the camera obscura as our proxy consciousness. How can something merely seen feel meant? "The unheard music hidden in the shrubbery / And the unseen eyebeam crossed, for the roses / Had the look of flowers that are looked at."[5] The artist is involved in an act of faith, the belief that things will work out, find a pattern, and resolve themselves. Of course, once a work is made it appears that it couldn't be any other way, but it is the finds and revelations, the recognitions that are allowed to flourish, that give the work resonance and unexpected life. It is from Morpheus, the god of dreams, the maker of shapes, we get the anamorphic lens.

A complex morphology is evolving onscreen as we watch Julie Mehretu in front of a computer quietly plotting the progress of a picture. Then with a jolting change of scale we see her sat cross-legged beneath a vast painting, the pattern and density of imagery a thought bubble, like treasure. Working with assistants on scissor lifts, the sheer scale of the enterprise invites comparisons from prehistory through the age of patronage, the Quattrocento to the New Deal where we arrive at the mural: a history replete with commissioned solidarity and dissent, corporate, civic, or communal pride. A mural is a statement as much as a painting—it is expected to perform. Murals have seen a bright tomorrow, a universalizing tendency that generally ends in grief. Mehretu takes capitalism in toto, by the horns, at one of its headquarters and finds in it a buoyant, abstract language: allusive, evocative, and densely realized, it seeks to take a corporate space and create a commonwealth.

Claes Oldenburg, on the other hand, is at the other end of the food chain, consumption-wise, with the made-in-China merchandising deals, where a dizzying miscellany of trinkets, ornaments, souvenirs, totems, jujus, and toys adorn the shelves of his studio. Without any readily available unifying principles or criteria to collate the world's ephemera, everything belongs to the order of the aesthetic. The director of our scrutiny is his scrutiny as we watch the artist picking, dusting, and placing things in an act of retrospection, putting his estate in order. His labors

are endless as this film is constructed as a continuous loop. A baseball hat and the hat from monopoly, a tiny Nike shoe, a small tin representing a French hotel, some soft violins, the Leaning Tower of Pisa, a tiny hamburger, a miniature key, saw, clothespin. The list could go on. Most of us have a drawer at home containing these indefinite articles; obscure objects that keep company with the old batteries, photos, screws, plugs—the metonymy and dreck of the past you can't quite lose because it has traces of your DNA on it. Oldenburg knows their value—how they posit some nagging questions. Is it too fanciful to think that these knick-knacks of popular Western culture arrayed in little reliquaries are its most telling belongings? Can these declamatory objects have a bona fide, independent existence outside of their brand, their bond to commerce? Are they all just empty signs? Can we forgive them their bad faith as objects? As he sets down each object one can't avoid imagining its gargantuan replica descending on some distant city plaza. "Copyright Claes Oldenburg" it reads under the image of an apple core on a mug: the artist's own merchandising.

In *Craneway Event* (2009), the methodology of Dean's filmmaking finds a remarkable and chiming analogy with Merce Cunningham's modus operandi. In the works he made with John Cage, music, or more fundamentally, sound was added once the dance had been created. "It is an addition—a huge one but still an addition."[6] Cage was keen to see how they could work separately from each other. "A way of thinking about sound and vision like the way thunder and lightning are."[7] Dean characteristically introduces "wild sound" at the editing stage and in this work it serves to make us feel all the more keenly the seemingly self-generating rhythms of the dancers and the sense of liberation in the work.

Here, in what was once one of Ford's biggest assembly plants, the body stands for itself, in gladness, not the body as an instrument in a factory—and there was never such light in a theater, nor freedom at work. Now it feels like a privilege, then Albert Kahn's architecture served to light up the three principles of Fordism: the standardized product, the assembly line, and cheap goods, which taken together amounted to a body sold into labor: the efficient automaton of *Modern Times*. It is all over

now, the end of work, retirement, the gold watch, obedience.
In the industrial age, post-production meant retirement, then
extinction or the afterlife. In Ford we trusted. All the profitable
work invested is redeemed in a temple of unwork in Edenville.
Consumer capitalism is a universal language but there is nothing
more resistant to commodification than silence.

"Is that clear? Yes, quickly to number two"—and a dancer
pushes the wheelchair-bearing Merce across his reflection, like
Proteus, the old man of the sea, or Canute, holding back the
years. Or, as Dean would have been acutely aware, like the
director: "Ok go!" he may as well have cried "Action!" His still-
ness, constancy, renders the actions evanescent, the dancers as
mayflies; we are aware of the brevity of a dancer's life measured
against the choreographer who has put generations through their
paces; his enduring spirit.

Magic hour, the reflections dazzle like the slick of water left
on the sand as the tide recedes. His dancers are acolytes, attentive
Children of the Sun. We watch from Merce's eye line in the chair,
level with the dancer's navel, the omphalos. Each dancer's body is
a sign: you read it from the center like the Vitruvian man.

"Ok, we'll try again." Merce patiently sets them about their
business, "One and two and one and go."

We watch as the dancers in their individuating rehearsal
clothes people this vast, empty building. Silent save for the
sounds generated by their movement—the squeak and stomp on
the floor and the gathering of breath. You could say it is a way of
being in the day, the practice of a discipline, which in the event
became the film. This is the rehearsal of the dance, not the work
itself. As such, it is an expression of limitless potential, because
its completion is infinitely deferred. Like unrequited love, it is
desire frustrated into the endless, stricken pursuit around the urn.
The music we will never hear.

Notes

1. John Keats, "Letter to Charles Brown, November 1820."

2. Stanley Plumly, *Posthumous Keats: A Personal Biography* (New York: W.W. Norton & Company, 2008), 345.

3. John Keats, "Ode on a Grecian Urn."

4. John Keats, "Letter to Richard Woodhouse, October 1818."

5. T.S. Eliot, "Burnt Norton, Four Quartets."

6. Author's notes.

7. Rebecca Milzoff, "The Natural," *New York*, April 2009, 74.

Five Americans

Texts by Tacita Dean

Craneway Event
A film with and about Merce Cunningham

When Merce died on July 26, 2009, I had just begun editing
Craneway Event. It immediately left me with an absence, which
I filled initially by watching recordings of Merce dancing in his
youth or chatting in interviews. When I returned to the film, I
realized that I was in the unique position of still being able to
work with him and to create something new, not only about him
but also with him. Although I lost the pleasure of imagining him
watching the film, I gained a different sort of Muse. Merce's joy
in the process was steadfastly there and his enthusiasm seemed to
have a directional force. I began to feel that Merce had set up the
components that make up the film—the building, the dancers, the
light, the ships, and the birds, because he knew they would not
fail him in absentia.

We filmed in what was once the craneway pavilion in a
former Ford assembly plant in Richmond, California. Albert Kahn
designed the factory with continuous glass to maximize the use
of daylight so the shifts in the movement of the sun transformed
the interior hourly. Merce loved the building with its views across
the water to the Bay Bridge and San Francisco. Working boats
and tankers passed in and out of the dock behind, while pelicans
swooped past mimicking the dance's motion. A pigeon wandered
the space. Merce directed and positioned the dancers, going from
stage to stage, tuning their movements. Watching him construct
the event over three stages stretched out in that enormous space
was like watching an abstract painter balance a painting, detail was
everything. As I edited the film, I heard him laughing and sing-
ing to himself, and taking such pleasure in it all, asking me in his
particularly resonant speaking voice, "Did you get that boat?" "Did
you film that bird?" "Did you see the light behind the dancer?"

Editing someone is intimate: you study them closely, sync to
the rustle of their clothing or the movement of their lips, and watch
them over and over again, hour upon hour. I spent this close time
with Merce and got to know him and understood more about his
process and his pictorial treatment of dance. He found his direction

early and never equivocated, yet he continued to find newness even from within his own originality and was never complacent, and nor did he tire. He remained fresh, open, and elastic to its possibilities, and had rare natural grace and immeasurable charm.

I was shocked to learn that Merce had died; he always appeared the trooper, in fine form and good spirit, hiding his frailty well. His death is a rupture; the end of something irretrievable—a last contact with the American avant-garde and the generation who stretched back to touch Dada and Surrealism, and who found their form through process, experimentation, and risk, and in the mutual respect they enjoyed in the relationships they made. Merce asked me to work with him on *Craneway Event*. It was, and is, an immense privilege and responsibility, which would have been daunting were it not for the fact that he was such good company in the cutting room, and that I felt trusted by him.

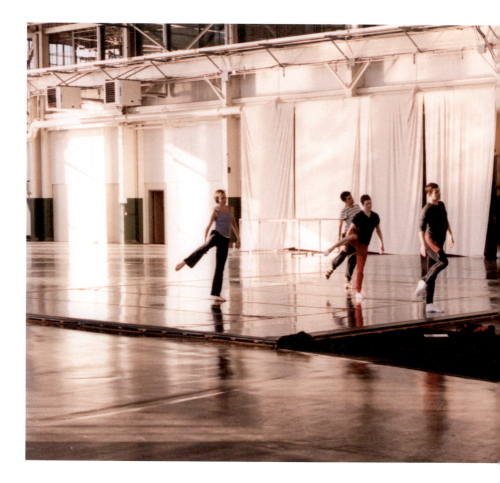

above and following four pages: *Craneway Event*, 2009 (stills). 16mm anamorphic film, color, optical sound, 108 min

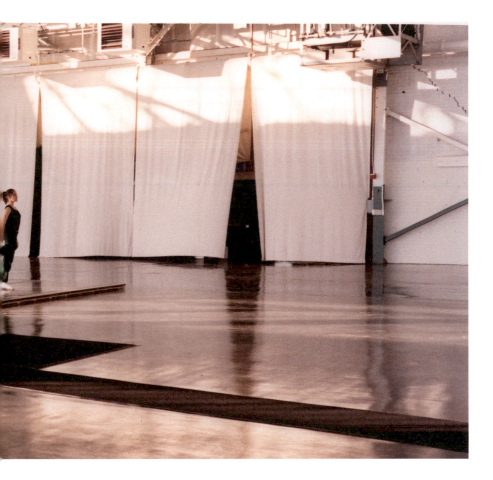

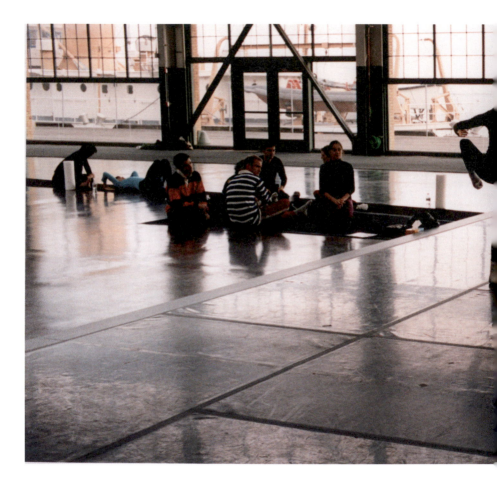

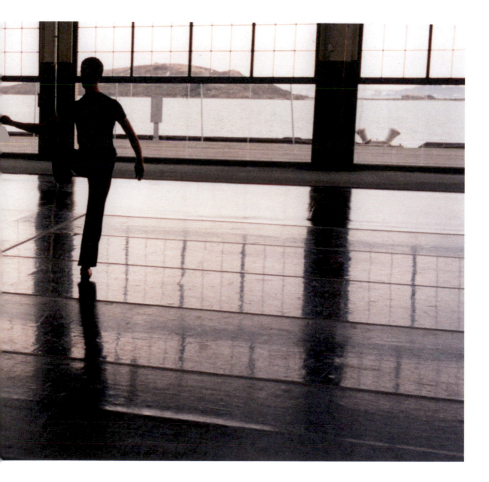

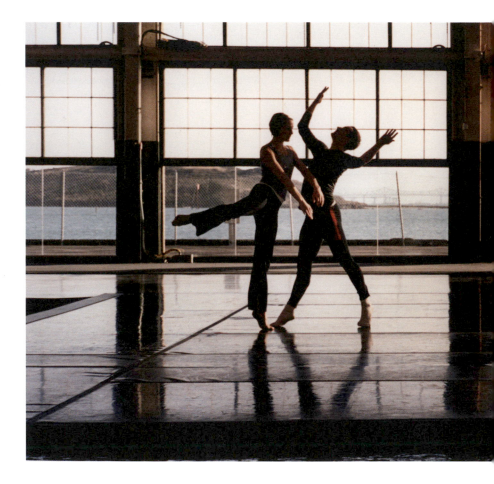

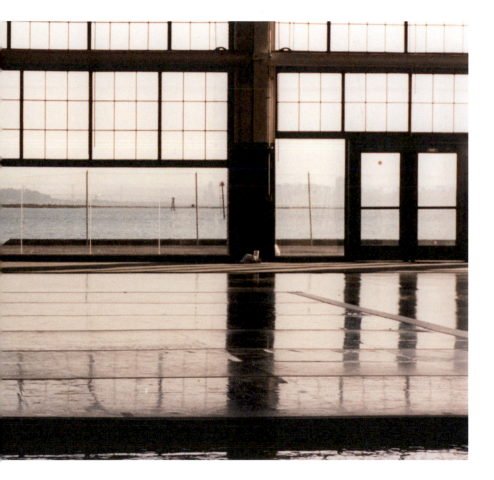

Edwin Parker

Why we become who we become, or do as we do, or are born with a facility for something when others are not, remains, for the most part, unknown to us. We cannot often guess what incident or influence arranged our lives or ambitions in the way that it did, or whether in fact it was something deeper. And most mysterious of all is why artists become artists, and why they become the artists they are.

I have loved the work of Cy Twombly since the beginning; it touched me immediately and I have never let it go, though I have grown and changed considerably since then. No matter where I encountered it, I was never disappointed. His work has been a constant in my life, but until recently, I had no idea who he was or what he looked like, nor was I inquisitive to know. He came out of another generation, another place, another world altogether. In a way, the maker was as distant to me as Michelangelo. And then I met him.

Lexington is a small town with a proud history in the southern state of Virginia. Its center is a lattice of two or three streets surrounded by eighteenth- and nineteenth- century houses, fraternity halls, and, in amongst the handsome trees and tidy grass, a university campus and military academy. It's an old-fashioned place, small-town and homely, with quirky notices stuck up in shop windows offering treats for pets with a purchase or advice on easy ways to get to Heaven. One of these humble premises Cy Twombly rents as his studio. Behind the blinds in its small storefront window he sits, thinks, and works, but mostly he sits, content to watch his neighbors pull up and park, buy cakes or their newspapers next door, and then leave again.

For Cy, painting is pure behavior and that's why he doesn't talk about. I asked him if he worked in spurts and he replied that he wasn't "nine to five." He is an artist blessed with pictorial instinct and with a true ability to work beneath his conscious level, and this is rare. Much of his working time is spent getting to this point. There is no preparation, or rather his preparation is sedentary, spent reading and reflecting and being. He doesn't hide

behind a process because, in a sense, he has no process, only the interaction in the moment, whenever it should occur.

Coming back to Lexington in the autumn each year, has allowed Cy to return home: home as in local. There is comfort in this and his affection for it is clear. Lexington, with its neo-classical architecture and pride in its history, was instrumental in making the artist in Cy. In the grounds of the Virginia Military Institute, he showed us a monument celebrating the site of a tree. Cy Twombly's paintings have a universal language but in Lexington, he is a local; he is himself, or at least his American self, and that is why I gave the film its proper name.

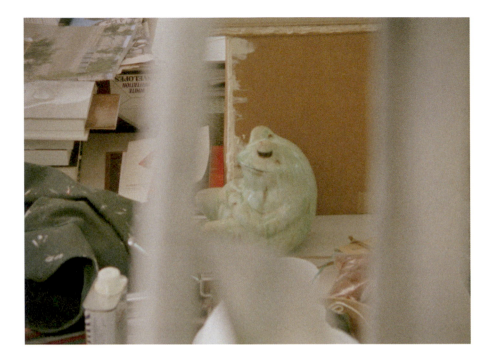

above and following six pages: *Edwin Parker*, 2011 (stills). 16mm film, color, optical sound, 29 min

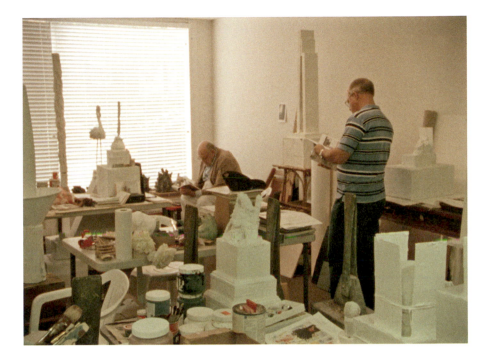

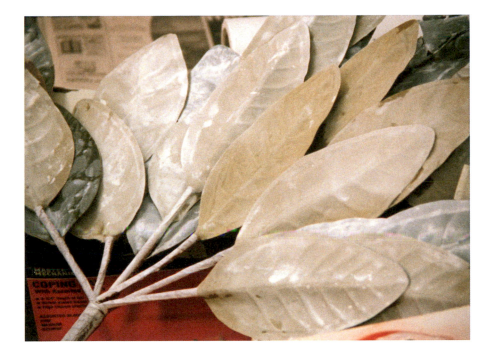

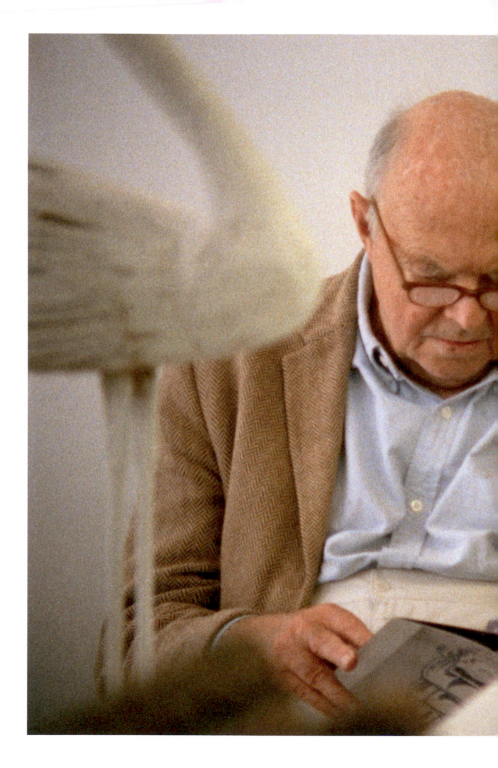

More or Less

Sitting talking with Cy Twombly in the Lexington Restaurant
after filming *Edwin Parker*, it came up that I was afraid of flying
but had to do it anyway to be the artist I was. He said that when
he was young, his mother watched him fret over his painting. She
said one day: "Why do you do it if it makes you so anxious? Why
don't you do something that makes you happy?" I said, "Does
painting make you happy now?" "More or less," he replied.

Earlier in that same week, I had met Leo Steinberg. On the
plane over I read his essay, "The Line of Fate in Michelangelo's
Painting." He had found by studying many subsequent versions
of the *Last Judgment* that the copyists appeared to "correct"
what they saw as compositional flaws in the original painting and
that this guided Steinberg to the real intent of Michelangelo. He
found what he describes as a deliberate but notional line run-
ning diagonally from the top left apex of the lunettes of Heaven
through the cut in Christ's side, down through the tormented face
of the sinner to Minos's genitals at the bottom right-hand corner
of Hell. At its exact center Michelangelo had painted himself—a
self-portrait—his own face appearing on the flayed skin of Saint
Bartholomew. To Leo Steinberg, Michelangelo had chosen to
place himself at the center of Judgment, equidistant from Heaven
and Hell—the artist representing all humankind.

As a student in my final year at the Slade, I started to pho-
tograph the changes I was making on a single blackboard on the
wall in my working space. Eventually, I turned the sixteen small,
dark prints into a work for my final show. Then they got lost.
Years later, they were found in a roll in a disbanded studio and I
could see how very little I had changed and that it made sense to
show them again.

All three of these incidents conspired to make *More or Less*.
I carried the title—still empty—from Lexington and tried again to
repeat the process behind *Sixteen Blackboards* by teasing myself
into making a drawing that came from the surface and the depths,
and what kept appearing were the diagonal and the line of fate.

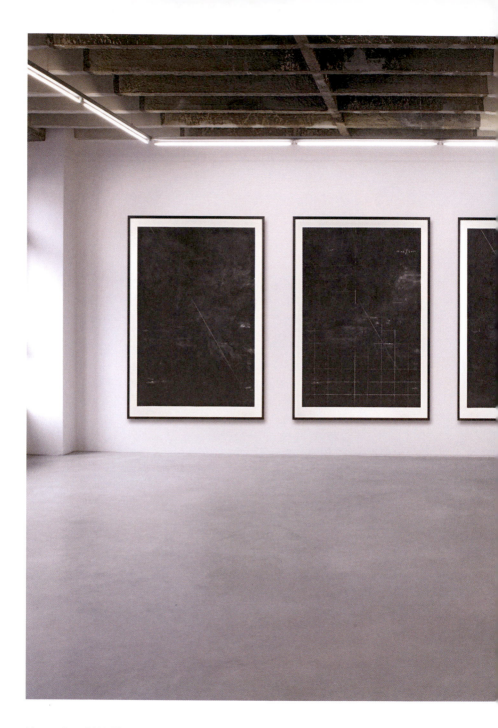

More or Less, 2011. Five gravures on Somerset White Satin 400 gr. paper, each 88 ⅝ x 59 in (225 x 150 cm)

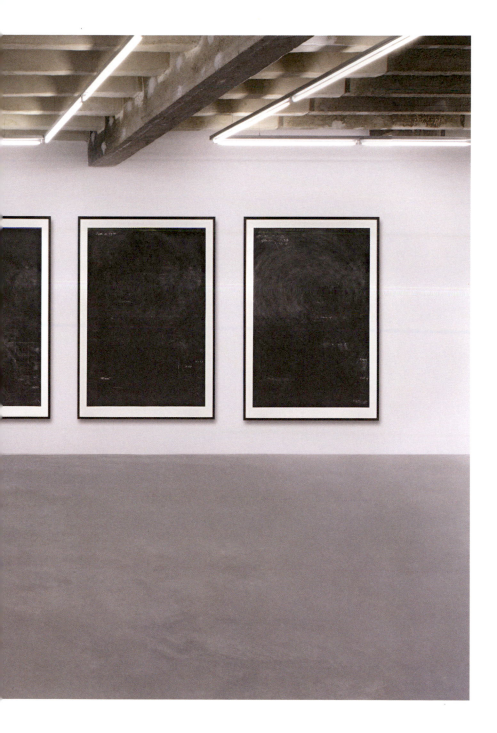

Manhattan Mouse Museum

Claes Oldenburg is a collector of non-valuable objects. All his life he has been gathering the ephemeral and the disposable, and keeping them as a resource and as an image/object bank of the temporarily pleasing, the fairground trinket, the newsprint advertisement, the household accessory, the novelty or toy. At a certain point in the 1970s, he acknowledged his collection: itemized, named, and exhibited it. He called it *Mouse Museum*.

We are not supposed to witness most of the objects in Claes's collection getting old. They are, of course, of the moment that made them. However, stranded out of their time and apart from their context, they can transform from negligibility to autonomous grandeur, and can take their place as objects in the world like any other. Claes knows this, as he is a master of the metamorphosis of the insignificant.

After the acknowledgment of *Mouse Museum*, Claes inevitably continued collecting and was no doubt given a fair few things from those who wanted to do the collecting for him. These hapless, second-generation objects were not given the same reception as their predecessors, but nonetheless were gathered and kept in white shelving in Claes's workshop on the ground floor of his studio.

One afternoon, Claes noticed them and began dusting and arranging them by category or otherwise, as he had done nearly forty years before with *Mouse Museum*. He found his objects absorbed him; he had missed them and tenderly he began encountering them again as individuals in his magician's cycle of transformation.

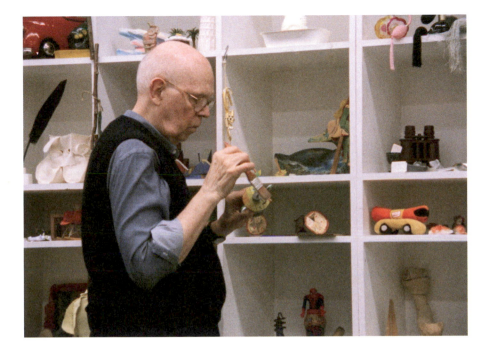

above and following six pages: *Manhattan Mouse Museum*, 2011 (stills). 16mm film, color, optical sound, 16 min

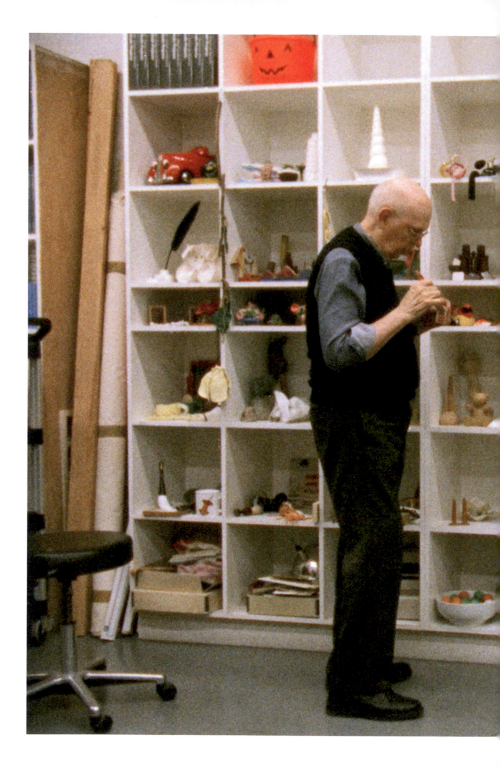

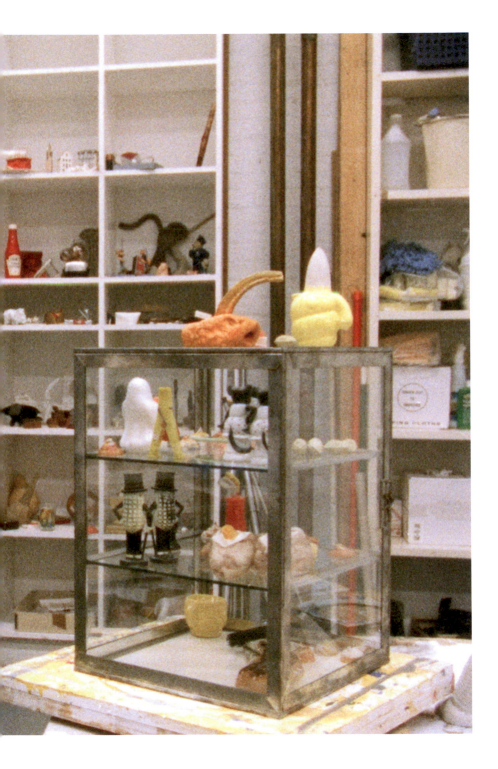

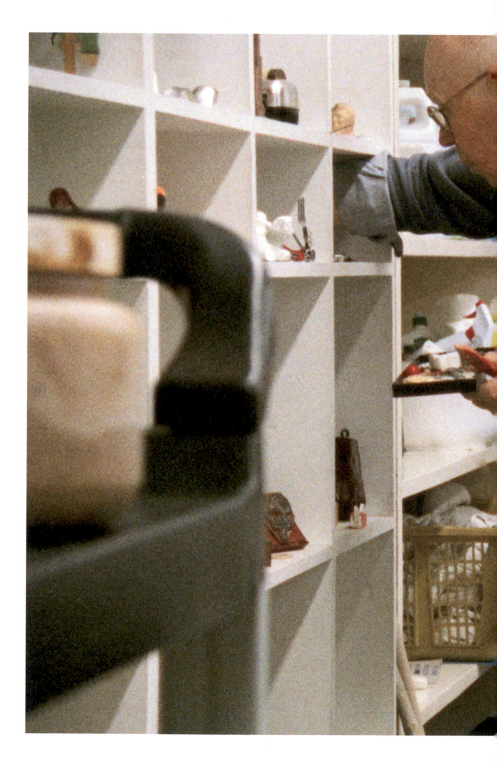

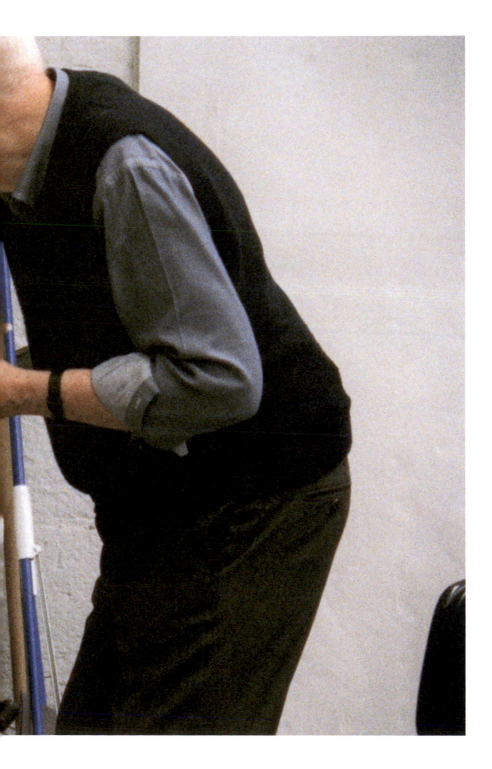

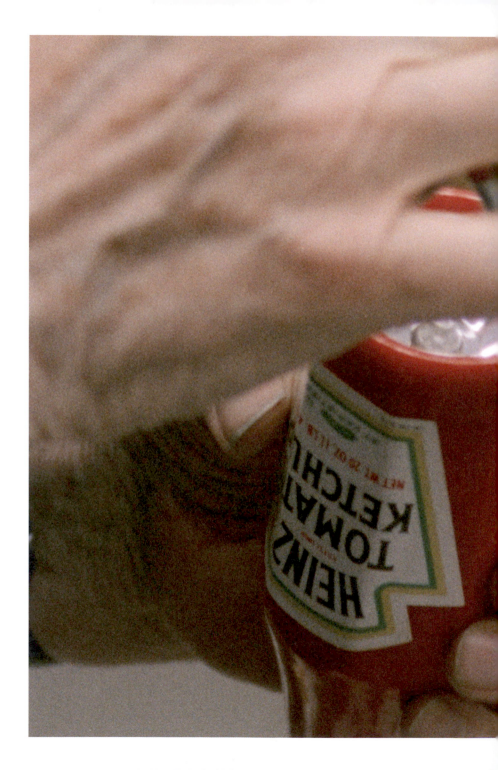

GDGDA

Julie Mehretu moved to Berlin to make a painting. She rented a large studio in a former munitions factory in the Ludwig Loewe Höfe, brought assistants over with her from New York, hired scissor lifts, bought overhead projectors, and imported crates of her acrylic paint from home. She needed to know what she was doing, and in this, she was unassailable. Goldman Sachs had commissioned her to make a work for the foyer of their new global headquarters, being completed just across from Ground Zero, and there was no time or room to dillydally; they had her under contract.

The decision to make the painting in Berlin, despite the organizational feat it entailed, offered Julie some welcome respite and necessary distance from Wall Street, especially when the financial world began imploding. Slowly, and with the necessary help of many assistants, she began embedding a complex lattice of meaning and information deep within the surface of the painting: plans, maps, and grids, trade routes, geometric shapes, and frontal elevations all became an undercurrent of banking meaning and fiscal power, which she abstracted into her own formal language.

The painting itself is longer than a tennis court, and in front of it, one is small. Julie named it *Mural*. I was awed by its manufacture and its complexity, and by Julie's rigor and discipline, and the ease and respect with which she delegated. The painting was taking on great authority and visual energy, and I had never seen anything like it. One afternoon and the following morning, I filmed a few moments of its construction in the studio, without any rigor or discipline of my own, but merely to bear witness to this rich and labored production, and the density of process involved in the making of this monumental work.

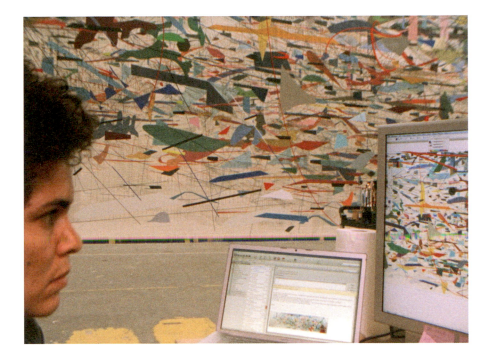

above and following two pages: *GDGDA*, 2011 (stills). Two 16mm films, color, silent, 4 min and 3 min

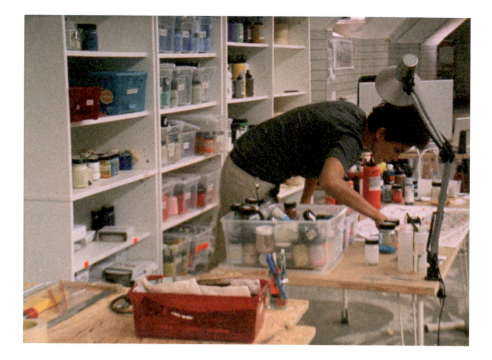

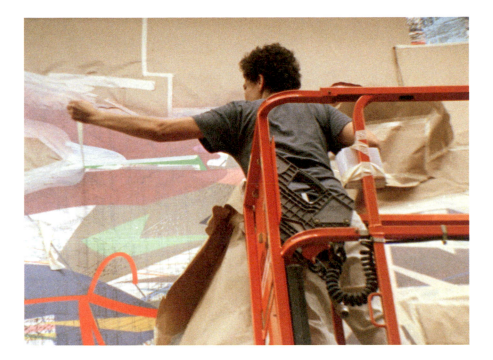

The Line of Fate

Leo Steinberg gave me one hour, and I understood why. He was trying to complete his book in the face of the inevitable and non-negotiable deadline that is one's own death. Aged ninety, shrunken and bearded, and irascible in his overheated and cluttered apartment on the Upper East Side, he made it clear that all interruption was intolerable. He had been writing his book on Michelangelo's early circular panel painting, *Tondo Doni*, for ten years. A small print of it was propped up in front of him as he wrote, without computer or typewriter, unmediated and by hand.

I had been attracted to Leo Steinberg through his essay, "The Line of Fate in Michelangelo's Painting," where he studied the significance of the diagonal in the work of Michelangelo, particularly in the *Last Judgment* in the Sistine Chapel. He saw in the fresco a hidden diagonal trajectory stretching from the vault of Heaven to the furthest corner of Hell, with the flayed skin of Saint Bartholomew and its distorted self-portrait of Michelangelo at the exact center point. Michelangelo was painting his own Line of Fate, placing himself at the center of judgment, for the individual is humanity judged. His prose style was straightforward and simple, and his ideas lovingly wrought from years and years of thinking and looking. I told him how much I loved his essay and that it was a relief to read something so clearly put. He replied that it took great effort to appear effortless.

My purpose was to photograph Leo's hands as he wrote, which I could see he saw as utterly pointless. Stealing myself against his impatience, I took three films—two in color and one in black and white, snapping fast as the clock ticked away time. As he got up to bid us leave, he talked of Eckermann's account of Goethe and that the greatest misery of old age was that one loses the right to be judged by one's own peers.

Back in Berlin, I put the photographs aside feeling that perhaps Leo had been right, and that the exercise had been pointless. Then, recently, as I shuffled them around, I caught sight of a serendipitous diagonal across five of the images—the appearance of a Line of Fate in the writing hand of Leo Steinberg.

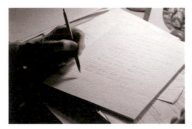

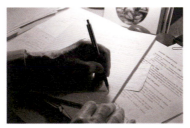

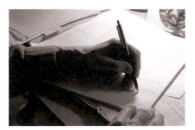

The Line of Fate, 2011. A vertical line of five photographs (four black and white and one color), 118⅛ x 35⅜ in (300 x 90 cm)

About the Artist

Tacita Dean was born in 1965 in Canterbury, Kent, UK, and currently lives and works in Berlin. She studied at Falmouth School of Art and the Slade School of Fine Art. She has had solo exhibitions at Tate Britain, London (2001), Museum für Gegenwartskunst, Basel (2000), MACBA, Barcelona (2001), and the Solomon R. Guggenheim Museum, New York (2006). Recent survey exhibitions of her work include "Analogue" organized by Schaulager, Basel, in 2006, and "Still Life" organized by the Nicola Trussardi Foundation, Milan, in 2009. Dean's most recent work *FILM* (2011) was conceived for the Unilever Series, Tate Modern's series of commissions for its Turbine Hall. Her work is in the collections of the Museum of Modern Art, New York, the Solomon R. Guggenheim Museum, New York, and Tate, London. Dean was nominated for the Turner Prize in 1998 and was the winner of the Hugo Boss Prize in 2006.

Works in the Exhibition

Craneway Event, 2009
16mm anamorphic film, color, optical sound
108 min

Edwin Parker, 2011
16mm film, color, optical sound
29 min

More or Less, 2011
Five gravures on Somerset White Satin 400 gr. paper
88⅝ x 59 in (225 x 150 cm)

Manhattan Mouse Museum, 2011
16mm film, color, optical sound
16 min

GDGDA, 2011
Two 16mm films, color, silent
4 min; 3 min

The Line of Fate, 2011
A vertical line of five photographs
(four black and white and one color)
118⅛ x 35⅜ in (300 x 90 cm)

All works courtesy the artist, Marian Goodman Gallery, New York/Paris, and Frith Street Gallery, London

PUBLISHED BY
New Museum
235 Bowery, New York, NY 10002
On the occasion of the exhibition, "Tacita Dean: Five Americans"
May 6, 2012–July 1, 2012

Curator: Massimiliano Gioni
Curatorial Associate: Margot Norton
Copy Editor and Publications Coordinator: Sarah Stephenson
Printing: The Avery Group at Shapco Printing, Inc., Minneapolis

"Tacita Dean: Five Americans" is made possible by the generosity of the Leadership
Council of the New Museum: Leyla Alaton, Alexandra Bowes, Michaela and Dimitris
Daskalopoulos, Nathalie and Charles de Gunzburg, Panos Karpidas, Pauline Karpidas,
Sandra and Panos Marinopoulos, Catriona and Simon Mordant, Sofia Nikolaidou and
Vasilis Bacolitsas, Patrizia Sandretto Re Rebaudengo, Maria de Jesus Rendeiro and João
Oliveira Rendeiro, Ellen and Michael Ringier, Tony Salamé, Pamela and Arthur Sanders,
Elisa Sighicelli and A. Ruben Levi, Caisa and Åke Skeppner, James Van Damme and Dean
Johnson, and Robin Wright.

PHOTOGRAPHY CREDITS
All images: Courtesy the artist, Marian Goodman Gallery, New York/Paris,
and Frith Street Gallery, London; pages 66–67: Courtesy the artist, Niels Borch Jensen
Gallery, Berlin, Marian Goodman Gallery, New York/Paris, and Frith Street Gallery, London

The texts "Edwin Parker," "Manhattan Mouse Museum," "GDGDA," and "The Line
of Fate" were all previously published in *Tacita Dean: Selected Writings 1992–2011*, part
of the box set *Tacita Dean: Seven Books Grey*. Göttingen: Steidl; Vienna: MUMOK, 2011.

The text "Craneway Event" was previously published in *Tacita Dean: Film works with
Merce Cunningham*, part of the box set *Tacita Dean: Seven Books Grey*. Göttingen: Steidl;
Vienna: MUMOK, 2011.

Cover: *Edwin Parker*, 2011 (still). 16mm film, color, optical sound, 29 min

ISBN: 978-0-9854485-0-9